# CHELTENHAM

## HISTORY TOUR

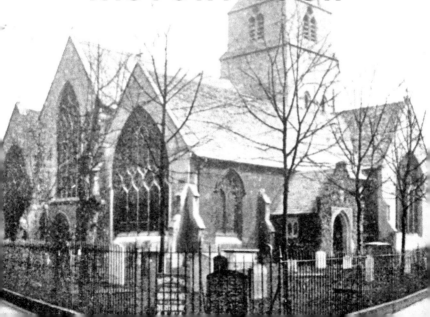

First published 2016

Amberley Publishing
The Hill, Stroud,
Gloucestershire, GL5 4EP
www.amberley-books.com

Copyright © Roger Beacham & Lynne
Cleaver, 2016
Map contains Ordnance Survey data
© Crown copyright and database right
[2016]

The right of Roger Beacham & Lynne
Cleaver to be identified as the Author
of this work has been asserted in
accordance with the Copyrights,
Designs and Patents Act 1988.

ISBN  978 1 4456 6610 5 (print)
ISBN  978 1 4456 6611 2 (ebook)

British Library Cataloguing in
Publication Data.
A catalogue record for this book is
available from the British Library.

Typesetting by Amberley Publishing.
Printed in Great Britain.

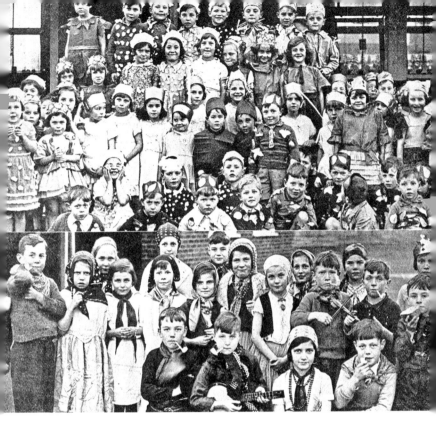

# HOP PICKERS

In August 1921, Cheltenham families set off on their annual holiday to Bosbury, Herefordshire by train, where they would all take part in hop picking.

# INTRODUCTION

The writer of Ecclesiastes reminds us that 'of making of many books there is no end'. This is certainly true of Cheltenham in recent years, as there have been a number of histories and photographic books published of the town. It is inevitable, therefore, that we will have reproduced some photographs with which readers will be familiar. However, we hope also to have included some that will be new to them. The majority of the photographs, with a few exceptions, are taken from a supplement to the weekly newspaper the *Cheltenham Chronicle* known as the *Gloucestershire Graphic*, printed between 1901 until the wartime paper shortage caused it to cease production in April 1942.

We hope older readers familiar with the town will find as much pleasure as we have had in rediscovering once-familiar but now long-vanished businesses and buildings. As a boy in the 1950s, I enjoyed peering through the windows of Honeysett and Howlett, electrical contractors and watch and clock repairers in Clarence Street. The premises had altered little since the 1920s. Within the shop, a Bunsen burner was alight and two elderly people could be seen at work, Mr Honeysett, doing electrical repairs, and a white-haired Mrs Honeysett, née Howlett, repairing clocks. Interest was added when my grandmother told me that we were related to the people inside, her

mother having formerly been a Miss Howlett. The shop has long since vanished, the site covered by the vast block of Cheltenham House. Another reminder of times past came upon seeing the photograph of the Cadena Oriental Café, with memories of the aroma of roasting coffee beans and, as a very small boy, of attending my uncle and aunt's wedding reception there. Although I could remember that it had been situated in the Strand, I was surprised at how completely it had been absorbed and remodelled by the neighbouring bank. For Lynne, having moved here from Yorkshire fifteen years ago, the experience of compiling this book has been a steep learning curve, bringing a new awareness of the town and its development. Even during the months we have been at work, the town has continued to change. Transformation occurs evermore rapidly and the importance of making a visual record now and in the years to come becomes increasingly important and necessary. We hope that our readers will find as much pleasure in recalling scenes of the past as we have had in assembling the collection.

# KEY

1. Grammar School, High Street
2. Bennington Street Market
3. Boots
4. Gas Offices
5. Drill Hall
6. Eye Hospital
7. Liberal Committee Rooms, Albion Street
8. Coliseum
9. Highbury Church
10. Gaumont
11. Winchcombe Street
12. Royal Hotel, High Street
13. Coopers Arms, High Street
14. The Priory
15. Sunningend, High Street
16. No. 411a High Street
17. Cadena Café, High Street
18. Cambray
19. Assembly Rooms, High Street
20. Lloyd's Bank, High Street
21. Star Hotel, Regent Street
22. Everyman Theatre, Regent Street
23. Cambray Spa
24. Steel's Garage
25. Queen's Hotel
26. Winter Gardens
27. Cadena Café
28. Imperial Spa
29. The Regal
30. Edward Wilson
31. War Memorial
32. Madame Wright's, Ormond Place
33. Cavendish House, Promenade
34. The Colonnade
35. The Colonnade
36. Olive's Shop
37. Cheltenham & Gloucester Building Society
38. St Mary's Church
39. Public Library
40. St Matthew's Church
41. Electricity Offices, Clarence Street
42. Fire Station

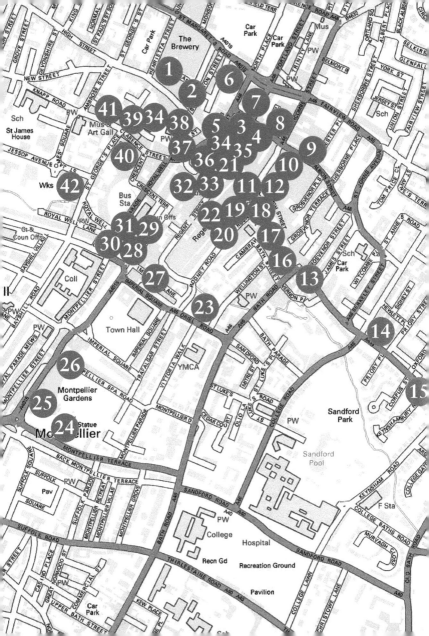

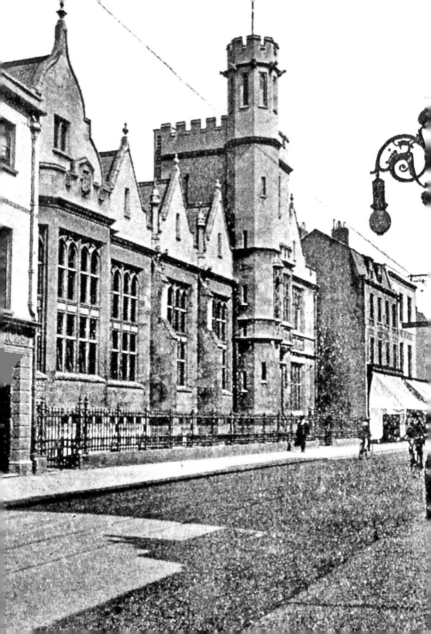

# 1. GRAMMAR SCHOOL, HIGH STREET

Rebuilt in 1887–89 in Tudor Gothic style, the boys' grammar school had stood on this site since 1572, when it had been founded by Richard Pate with a grant from Elizabeth I. Alumni include the composer Gustav Holst, parson poet R. S. Hawker, Frederick Handley Page, aeronautical engineer, and Benjamin Baker, civil engineer and designer of the Forth Rail Bridge. The school relocated to new premises at Hesters Way in 1965 when a bland retail block was erected here. In turn, this is currently being redeveloped as part of the brewery complex.

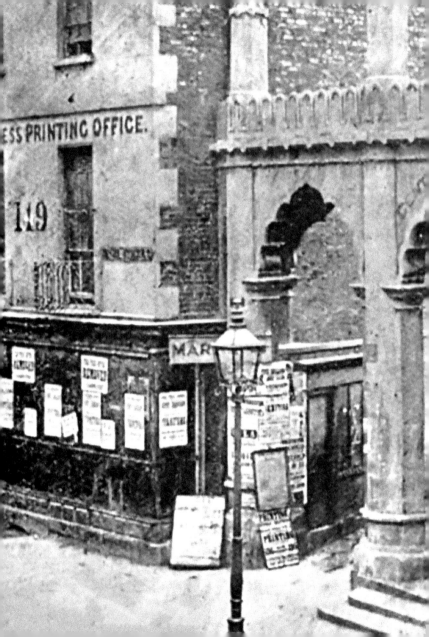

## 2. BENNINGTON STREET MARKET

Photographed probably just before its demolition in 1876, this shows the Mughul Indian-style entrance to the market on the site of the present Bennington Street. Just visible are the words 'centre stone', which were replaced by a new stone on the property on the right, as can be seen on the following page.

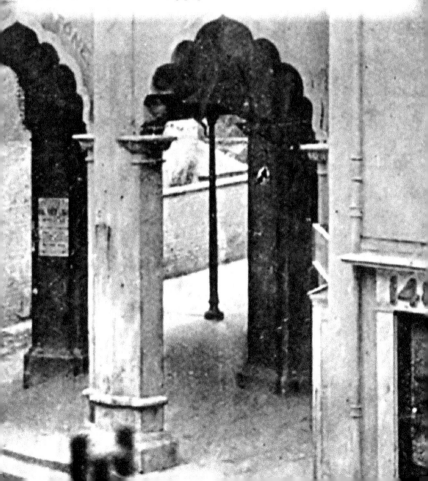

# 3. BOOTS

In 1924, Boots the chemists announced plans to completely rebuild their premises at the corner of North Street and High Street. The imposing, pedimented new building opened in 1927 and offered, as well as medical and surgical requirements, a café, a subscription library, an art gallery and a book department.

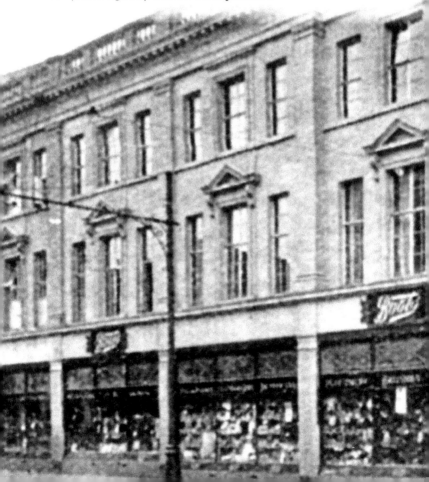

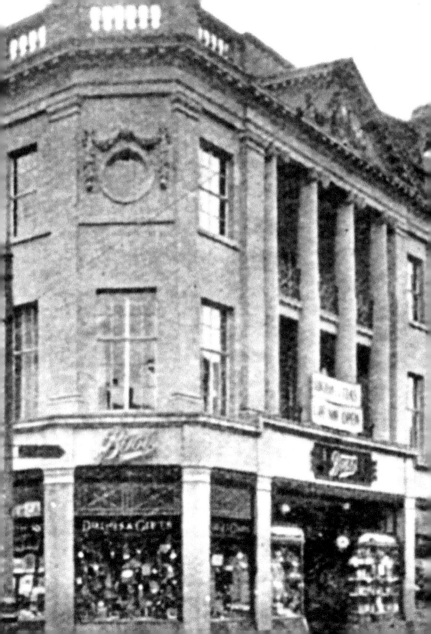

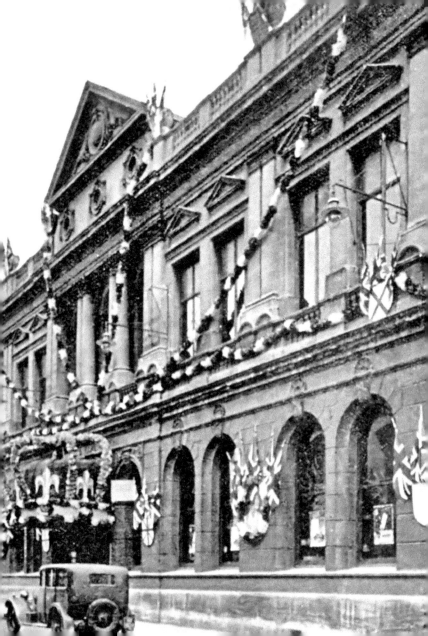

# 4. GAS OFFICES

Here, decorated for the coronation of George VI in 1937, are the late Victorian gas offices situated at the corner of North Street and Albion Street. Demolished around 1962 and replaced by a furniture store, that building has since been incorporated into the expanded Boots, sadly now without its café and library.

# 5. DRILL HALL

Designed by local architect H. T. Rainger for the Gloucestershire Regiment Volunteer Battalion, the drill hall in North Street was officially opened in 1906 by Field Marshal Earl Roberts, VC. For the occasion, Roberts stayed with his old comrade Colonel Cunliffe Martin at Delmar in Montpellier Terrace and large crowds lined the route to see the field marshall pass by. The drill hall was demolished many years ago and today the site is inhabited by the Primark clothing store.

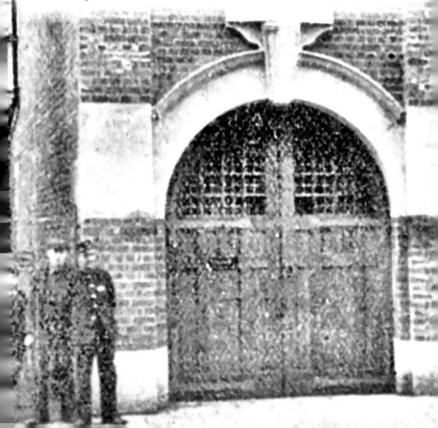

CHELTENHAM & DISTRICT LIGHT RAILWAY

CHELTENHAM DISTRICT LIGHT RAILWAY

PARCELS OFFICE

# 6. EYE HOSPITAL

Founded at No. 2 North Place in 1889 by Dr F. A. Smith, the Eye, Ear & Throat Free Hospital moved across the road to Edmonstone House ten years later. A new wing for outpatients was added in 1908, and further expansion took place in 1911 when another storey was added to the wing on the left, subsuming the furthermost bow on the right. The hospital remained on this site until the mid-1930s, when purpose-built wards were added to the General Hospital.

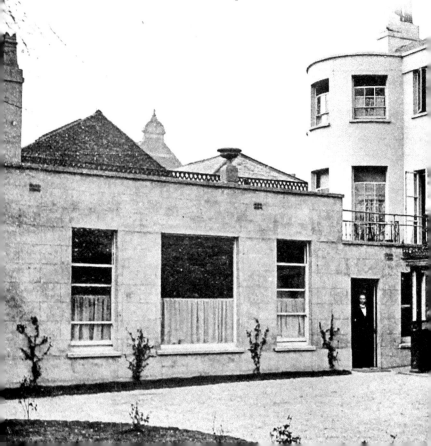

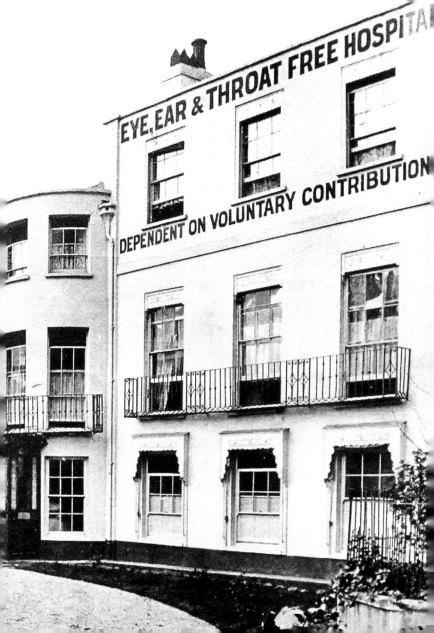

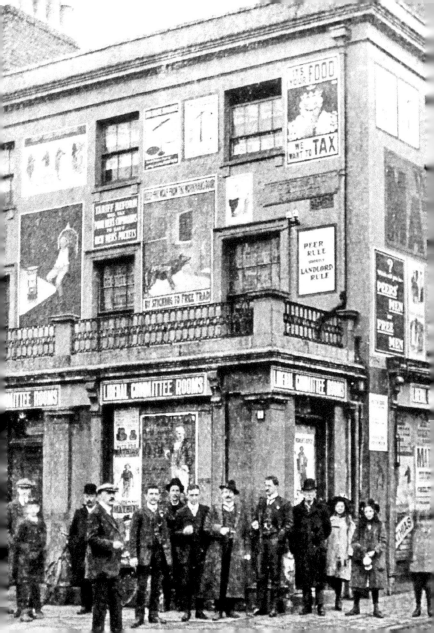

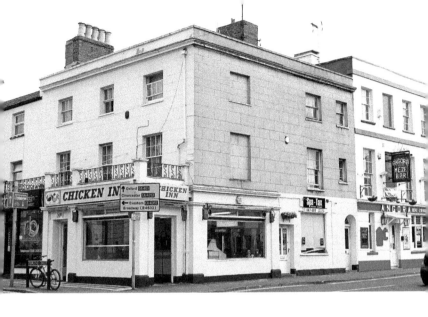

# 7. LIBERAL COMMITTEE ROOMS, ALBION STREET

In 1910, two general elections were held. At the first, in January, Viscount Duncannon was elected as the Conservative member for the town, though the election resulted in a hung parliament. At the second election in December, Richard Mathias was elected for the Liberals. Though the Conservatives, together with the Liberal Unionists, gained the greater number of votes, the Liberal Party, with the support of the Irish Nationalists, formed a government. Mathias' election was declared void on petition and, at the by-election in April 1911, James Agg-Gardner, by a narrow majority, regained the seat for the Conservatives. Here are shown the Liberal Committee Rooms at the junction of Portland and Albion Streets in December 1910. Today the premises are occupied by a hairdressers and a fast-food outlet.

# 8. COLISEUM

Originally the smart showrooms and workshops of furniture maker John Alder, this Georgian building in Albion Street became the Conservative Club in 1881. It can be seen here covered in posters for the 1909 General Election.

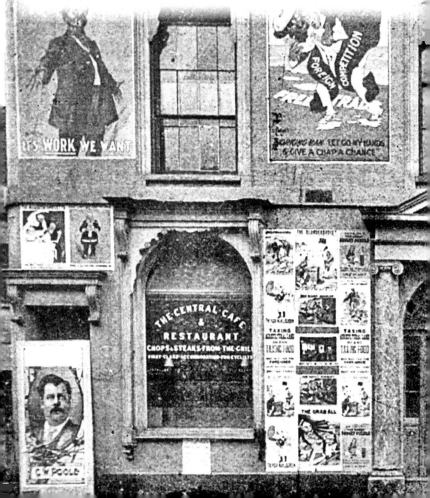

**LOOK HERE MATES!**

**TARIFF REFORM**

**A FREE TRA**
**VICTIM**

**IT'S WORK WE WA**

**ANTIQUE**
**FURNITURE**

**TO BE LET**

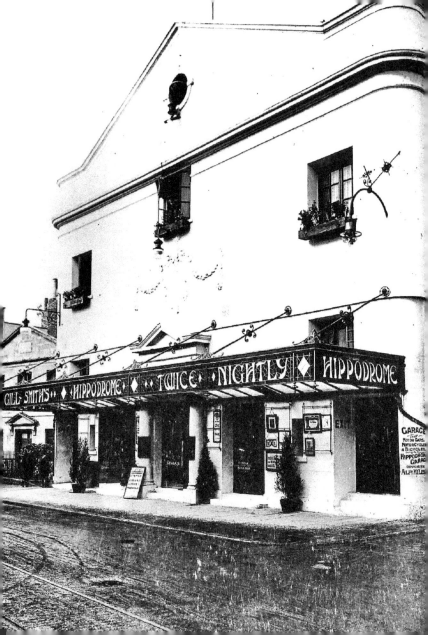

# 8. COLISEUM

The early years of the twentieth century saw variety entertainment flourish, especially after the first Royal Command Performance in 1912. Retaining the façade of the former building, Cecil Gillsmith opened the Hippodrome on this site in September 1913. One week, the twice-nightly performances included the young Gracie Fields. Renamed the Coliseum in 1920, it became a cinema in 1931 and later a bingo hall and snooker club before ending its days as a bar and club. In 2010/11 it was replaced by an apartment block that retains the name the Coliseum.

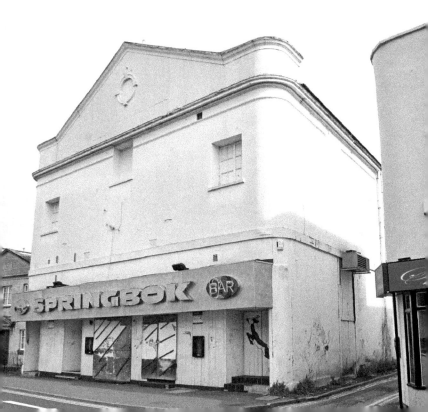

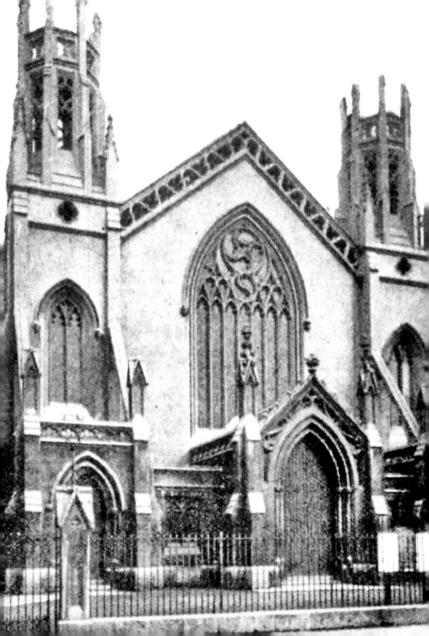

# 9. HIGHBURY CHURCH

There was talk of divine retribution when it was announced that Highbury Congregational Church in Winchcombe Street was to be demolished to make way for a cinema. Built in 1850–52 in a Gothic Revival style, it had succeeded the first chapel opened in Grosvenor Street. The last services were held here in February 1932 when the congregation moved to its present building in Priory Terrace.

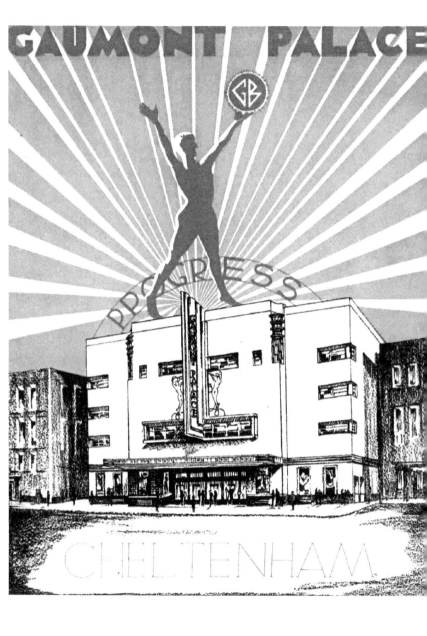

# 10. GAUMONT

Designed by W. E. Trent, the new Gaumont Palace opened with Conrad Veidt in Rome Express on 6 March 1933. Later known as the Odeon, it had been built with full stage facilities and presented variety shows, pantomimes and pop concerts. When the Beatles appeared here in November 1963, hordes of screaming fans surrounded the building. Closed in 2006, the cinema has been replaced by a Regency pastiche residential and commercial development named, with little imagination, Regency Place.

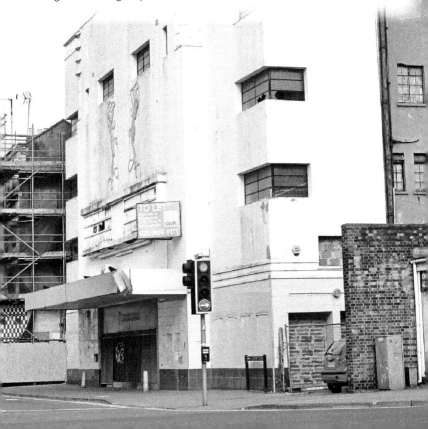

## 11. WINCHCOMBE STREET

Looking from the High Street towards Winchcombe Street in 1923, the shop on the right, lately occupied by F. E. Higgins, portmanteau maker, was about to be demolished to make way for a Swiss chalet-type building belonging to Dunn's the hatters. It was suggested that at the same time the road be widened by taking back the building on the left by 2½ feet, then occupied by Lloyd and King chemists. However, when Winchcombe Street was redeveloped in the mid-1960s, it was the right side that was set back, the corner property now being occupied by a branch of the TSB bank. The shop on the left, at present occupied by Thomas Cook, travel agents, remains relatively unchanged.

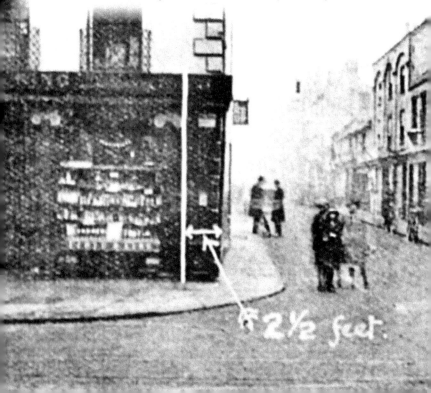

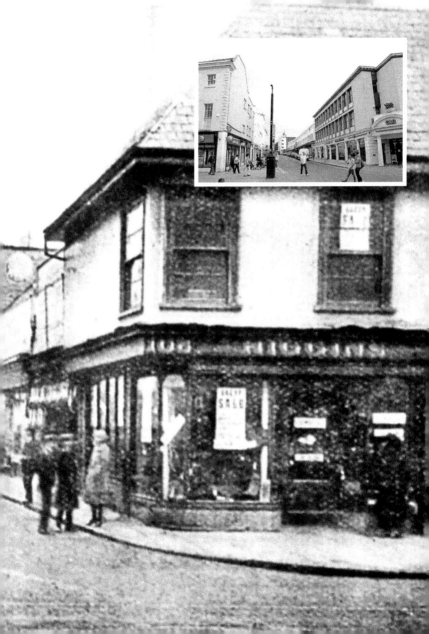

## 12. ROYAL HOTEL, HIGH STREET

Built on the site of the house of John de la Bere, the town's chief magistrate who died in 1795, the Royal was one of several hotels and inns in the High Street that survived into the twentieth century. Shown here in around 1925, it was little altered from its Regency appearance. During the early 1950s, a uniformed commissionaire stood outside the entrance, but by the end of the decade the hotel had been replaced by a huge Woolworths store. This in turn was replaced by the £35 million Beechwood Place shopping arcade that opened in March 1991. The building housing the Cotswold Pharmacy, though extended, is still recognisable and is now a dental and optical centre.

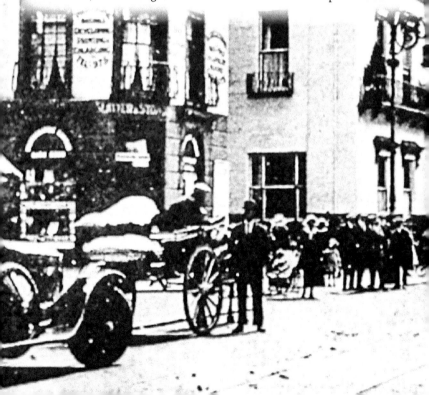

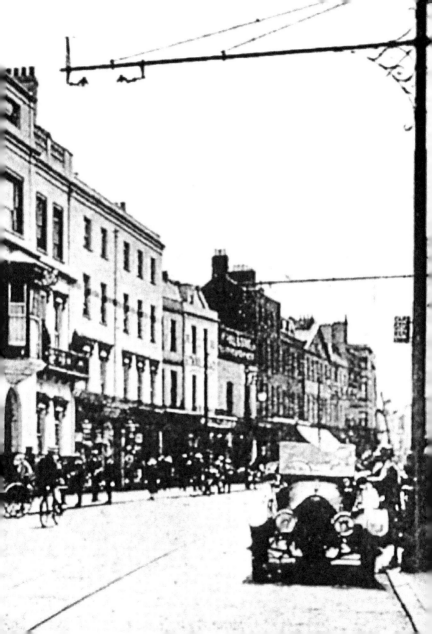

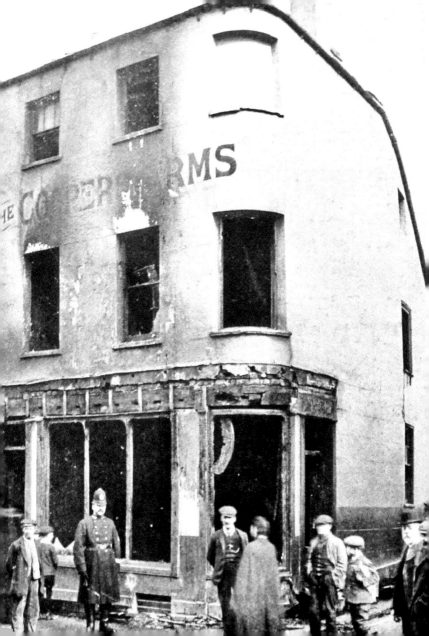

# 13. COOPERS ARMS, HIGH STREET

Almost totally destroyed by fire in 1909, the Coopers Arms in the High Street was rebuilt by the owners, the Original Brewery, in some style. Green glazed tiles bear the raised lettering 'Ales & Stout' and 'Wines and Spirits'. Above the centre door is a ceramic plaque, one of the many once common in the town, bearing the legend 'West Country Ales Best in the West'. Renamed Cactus Jacks in the late 1980s, it is today the Vine, more of a wine bar than pub, and has expanded to include buildings at the rear in St James' Street.

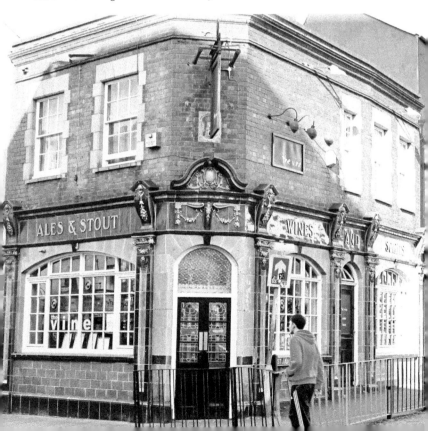

# 14. THE PRIORY

Built to a Greek Revival design in the 1820s, the Priory was originally two houses – Priory House to the left and the Priory to the right. The Master of the Ceremonies, Charles Marshall, lived at the Priory and entertained the Duke of Wellington here in August 1828. The building was later used as a hostel by the students of the Colleges of St Paul and St Mary but was redundant by 1959. Its proposed demolition in 1961 brought a flurry of protests, but the building continued to decay and was demolished in 1968. It was replaced by an office block, Mercian House, which in 1999 was replaced by Wellington Mansions, an apartment block whose design echoes that of the original building. A plaque on the building commemorates the social reformer Josephine Butler, who lived at the Priory while her husband was master at Cheltenham College.

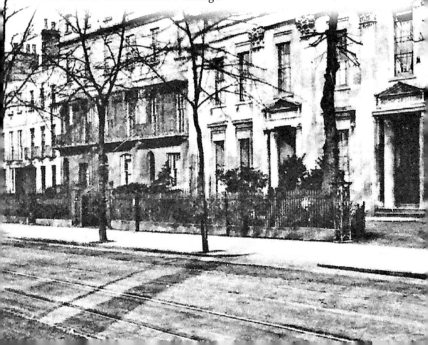

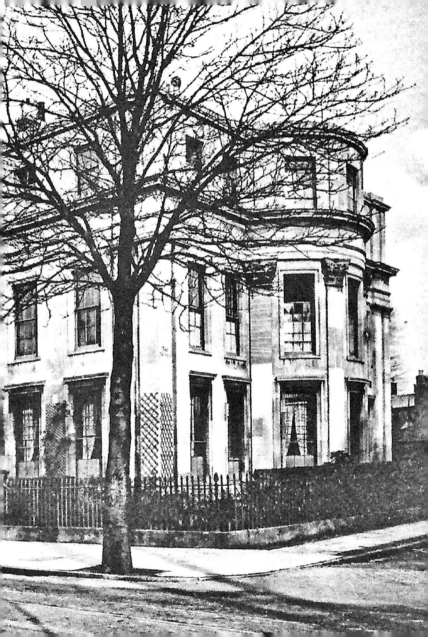

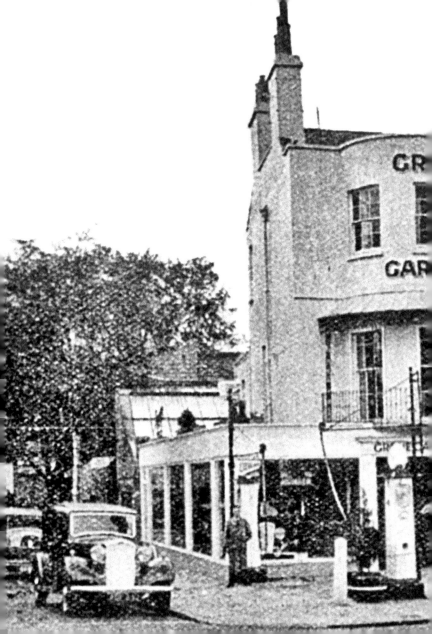

# 15. SUNNINGEND, HIGH STREET

Originally an elegant Regency villa, Sunningend, at the corner of College Road and High Street, became the workshops and showrooms of H. H. Martyn in 1888. The company became one of the leading producers of architectural carving in wood, stone and metal, and a plaque on the building now commemorates their occupation. Sunningend is shown here in 1936 as Grove Garage complete with petrol pumps. Older residents will remember the building as the Rolls-Royce showrooms of Messrs Broughton. Now known as Stirling Court, it has been skilfully converted into offices.

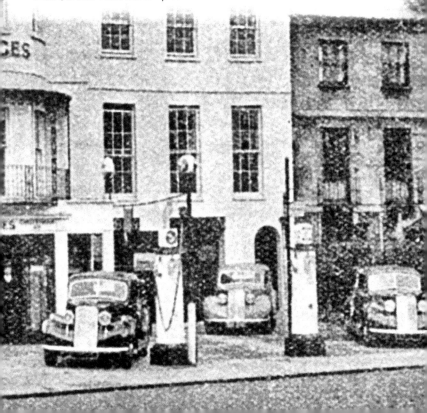

# 16. NO. 411a HIGH STREET

Due to be demolished in 1924, the building, occupied for many years as a greengrocers and fruiterers at No. 411a High Street, was described as 'one of the last of the old fashioned, low ceiling shops'. Standing in the part known as the Strand and since renumbered Nos 82 and 84 High Street, the present undistinguished building houses a pizza shop and jewellers on the ground floor, with a hairdresser above.

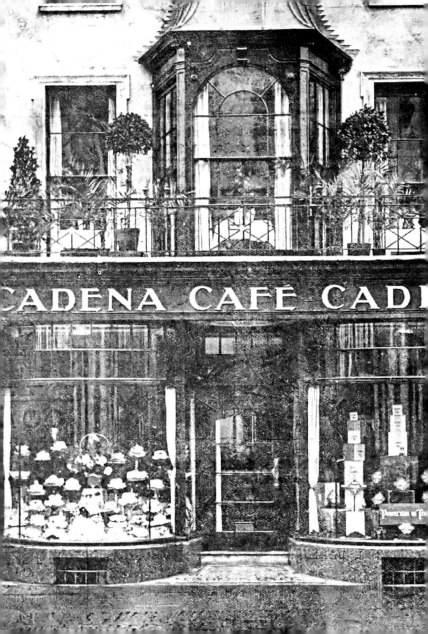

# 17. CADENA CAFÉ, HIGH STREET

Photographed in 1921, after being completely refitted, is the Cadena Café at No. 126, High Street. Known as the Oriental, it had been acquired in 1919, together with the Cosy Corner in the Promenade, by Cadena Cafés Ltd from E. E. Marfell. For many years, the upper room was the venue for wedding breakfasts and other happy occasions, while passersby would be drawn by the aroma of roasting coffee beans. The café has long been absorbed by the neighbouring branch of Barclays bank.

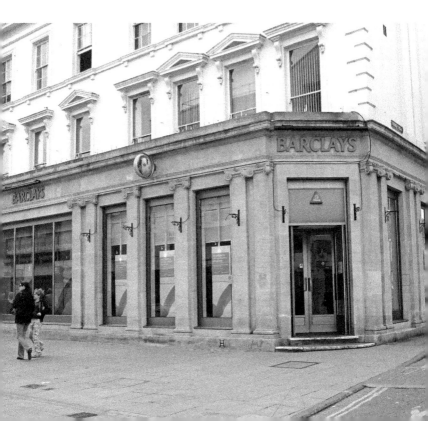

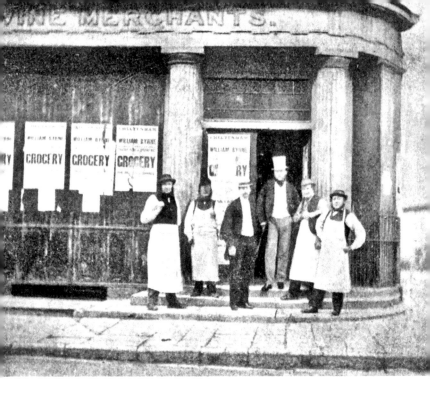

## 18. CAMBRAY

Standing at the corner of High Street and Cambray Place, this imposing building, with its Greek Doric columns, is shown in George Rowe's guide of 1845 as occupied by Mathews & Co., grocers. Later occupied by the London Supply Co., the photograph shows auctioneers outside the building, which was demolished about 1906. Replaced by the present red-brick building, now housing a betting shop, older residents will recall the popular Clock Restaurant there run by the Chrisanthou family.

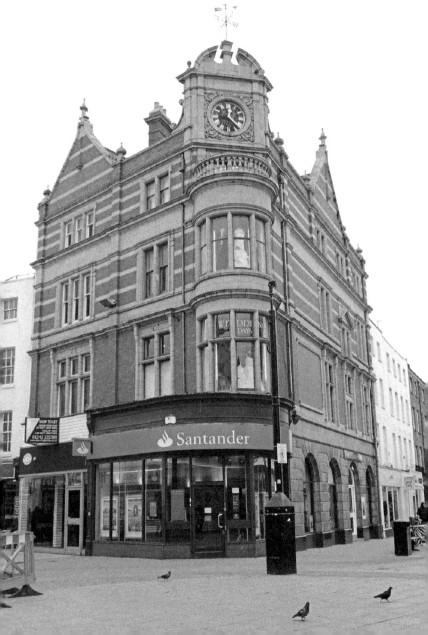

## ASSEMBLY ROOMS, CHELTENHAM.

# THE ANNUAL JUVENILE BALL

### WILL TAKE PLACE

*On WEDNESDAY NEXT, JANUARY 17th,*

Commencing at 8·30 p.m., terminating at 2 a.m.  Juveniles have precedence until 11 p.m.

Stewards—Col. CODDINGTON, T. ROME, Esq., J. H. LOCKE-JONES, Esq., R. CRAIGIE HAMILTON, Esq., and C. C. TURNBULL, Esq.

The Committee will meet at the Rooms from 12 to 1 mid-day, and from 3 to 4 p.m. on the day of the Ball, for the purpose of issuing Tickets.  Non-Subscribers' Tickets, 7s. ; Juveniles (under 14 years of age), 3s. 6d.

The Orchestra will be under the Direction of Mr. P. JONES.

## ASSEMBLY ROOMS, CHELTENHAM.

TWO   GRAND   PROMENADE

# CAFÉS CHANTANTS,

### INCLUDING

# Variety Entertainments and Refreshments,

*On SATURDAY, JANUARY 27th,*

**In Aid of the War Fund for Officers' Widows and Families,**

Doors open at 3 p.m. and 8 p.m.

Tickets, Four Shillings each inclusive, if taken before January 25th, after which date Five Shillings, can be obtained at BANKS' Imperial Library, Cheltenham.

# MISS
# CLARA BUTT'S
# GRAND EVENING CONCERT,

*MONDAY, JANUARY 29th,*

## AT THE ASSEMBLY ROOMS.

Tickets now ready at DALE, FORTY & Co.'s Pianoforte Galleries.

# 19. ASSEMBLY ROOMS, HIGH STREET

Shown here is a print of 1856 of the Assembly Rooms, which stood at the corner of the High Street and Rodney Road. Opened by the Duke and Duchess of Wellington in 1816, they were the centre of the town's social life, hosting balls, concerts, lectures and other activities. They were demolished in 1900 when the new town hall took over many of the Rooms' functions. The adverts, from *The Looker On*, the society weekly paper, are advertising a ball in 1834 and a variety of events in January 1900.

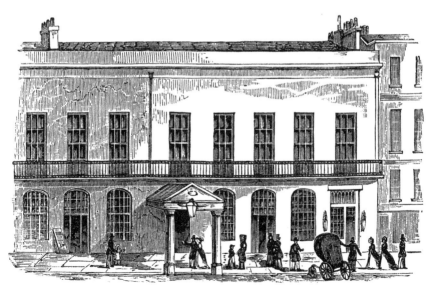

The Assembly Rooms.

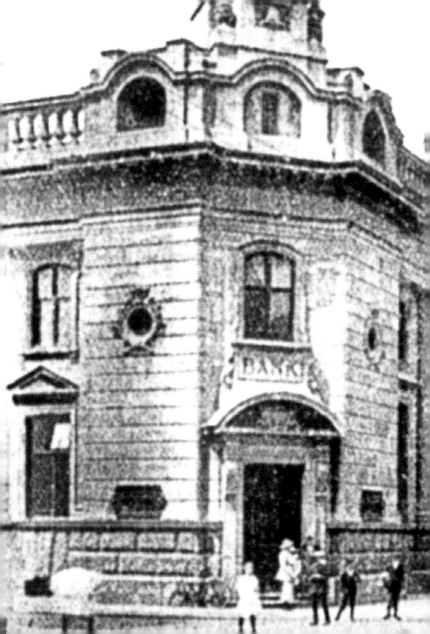

# 20. LLOYD'S BANK, HIGH STREET

On the site Waller & Son, also architects of the town hall, designed a neo-baroque building for Lloyds Bank, whose new banking hall (though described by one writer as 'somewhat ponderous') looks as if it could be an assembly room itself! Note the tram standard outside the bank in the photograph of 1917. In addition, note the 'Dragon and Onion' lamp stand, examples of which can still be seen in the town, notably in the parish churchyard.

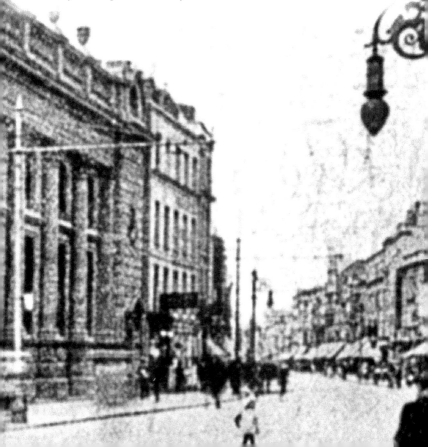

## 21. STAR HOTEL, REGENT STREET

In continuous use as a public house since the 1820s, the Star Hotel in Regent Street is shown here in 1838, when the landlord was William Dangerfield. Today it is known as Copa, but the Star will be remembered by many as the Berni Inn, popular for family meals.

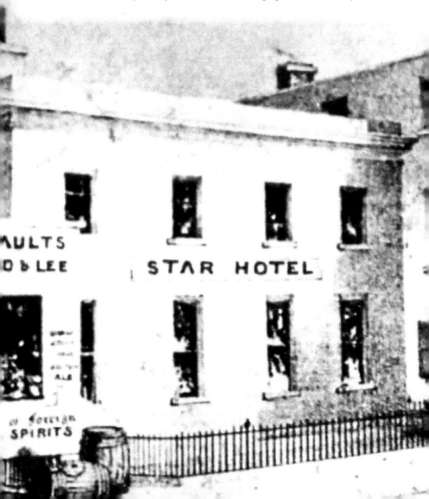

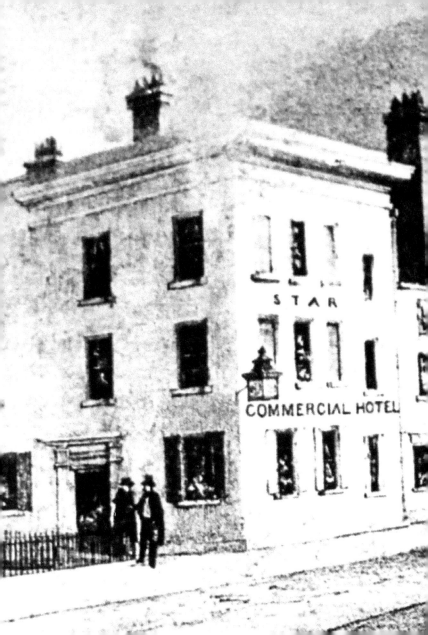

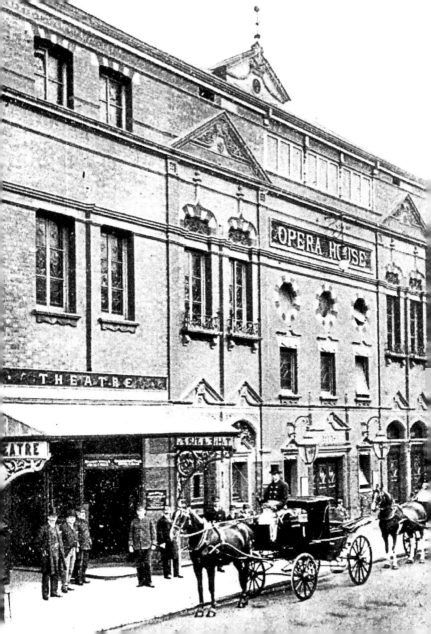

# 22. EVERYMAN THEATRE, REGENT STREET

Opened on 1 October 1891 by no less a figure than Lillie Langtry, 'the Jersey Lily', the Opera House in Regent Street was designed by the leading theatre architect of the day, Frank Matcham. Seen here around 1910, its undistinguished façade gives no clue to the riches inside, the ornate plasterwork of which has been described as the 'splendidly sugary rococo interior'. A touring theatre, many of the great players of the past have appeared here from Little Tich and Ellen Terry, to Edith Evans and John Gielgud. Renamed the Everyman in 1960, the present façade dates from the 1980s. A small plaque, placed here by the Frank Matcham Society, records the fact that this is now one of his earliest surviving buildings.

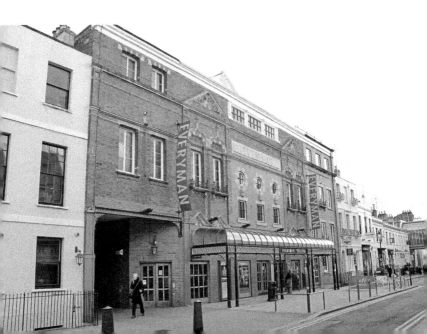

## 23. CAMBRAY SPA

The octagonal Cambray Spa, built in 1834 by Baynham Jones of nearby Cambray House, stood at the corner of Rodney Road and Oriel Road. It was converted to a Turkish Baths in 1873. The inset image shows William Brown (on right) of Tivoli, and his father working on the conversion. Brown also worked as a sculptor on the Houses of Parliament and was responsible for many of the caryatides in Montpellier Walk. The baths were demolished to make way for the present car park in 1938.

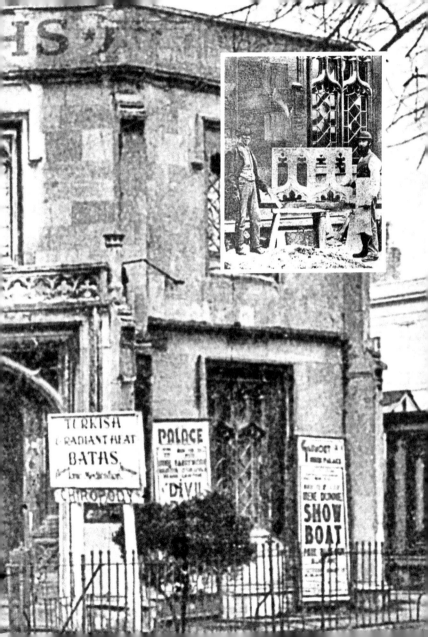

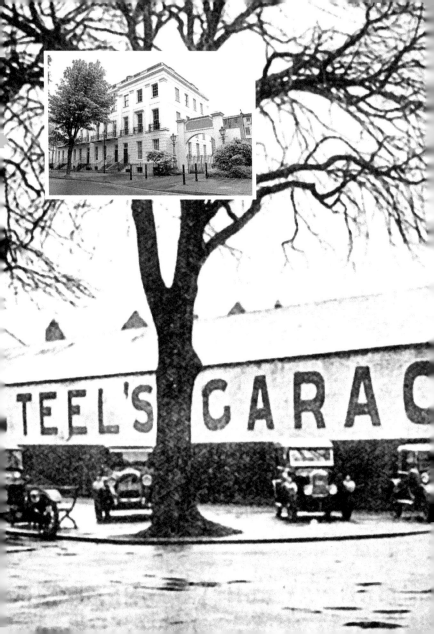

# 24. STEEL'S GARAGE

Shown in 1926, H. E. Steel's Garage displays the Royal Arms above the entrance to the former stables of the Queen's Hotel. Since 1996, the site has been occupied by the Broadwalk apartment block, echoing the architecture of the east side of Imperial Square. Two Victorian lamp stands, surmounted by crowns, still stand at the apartments' rear entrance, while, closer to Vittoria Walk, the so-called Napoleon Fountain can be seen, which once stood on the site of the hotel.

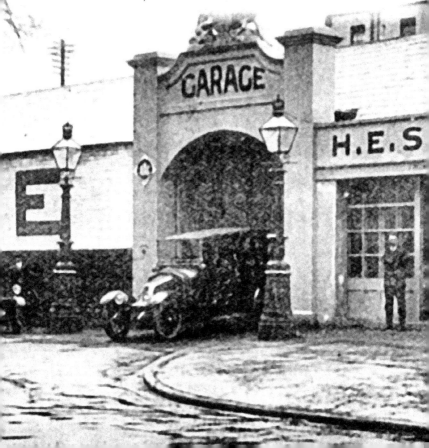

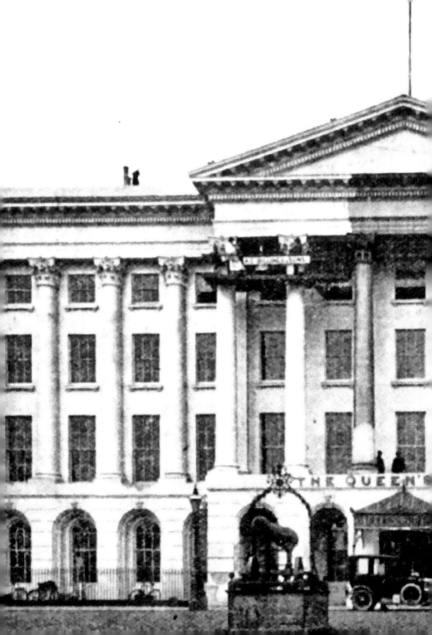

## 25. QUEEN'S HOTEL

Shown here in 1926, the Queen's Hotel has a commanding position at the head of the Promenade. When opened in July 1838, rooms were advertised at between 10d and 17½d, with servant's rooms available at 5d per night. Though its architecture is redolent of St Petersburg, it featured as the fictional Hotel der Konigin in the 1985 TV blockbuster, *Jenny's War*, set in 1941 Leipzig. Over the years, guests have included many of the musicians and actors who have appeared in the town, including Adelina Patti, Nellie Melba, Ignacy Paderewski and Sarah Bernhardt. The future Edward VII lunched here as the Prince of Wales in May 1897 and, in March 1990, Britain's first female prime minister stayed here, together with five members of her Cabinet.

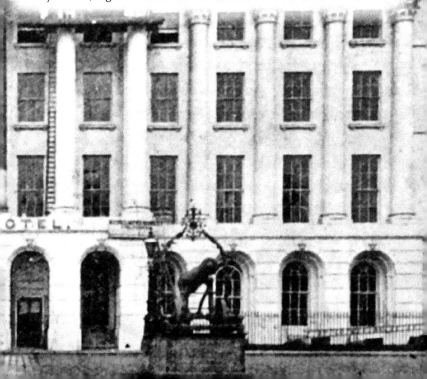

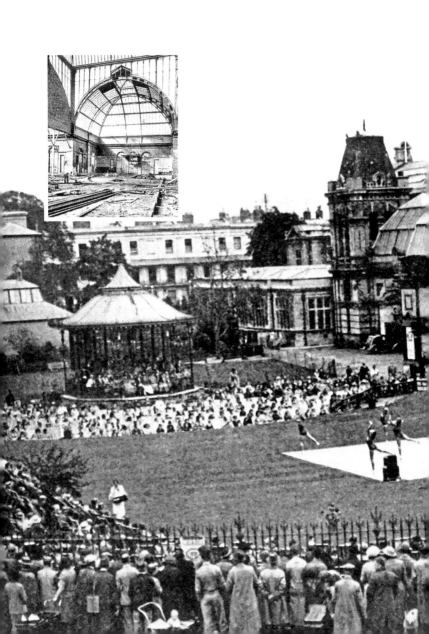

# 26. WINTER GARDENS

Opened in 1878, the Winter Garden provided a multipurpose venue for concerts, circuses, balls and concerts. In a poor state of repair, it was demolished at the beginning of the Second World War. The *Daily Mirror* 'eight' gymnasts can be seen here in August 1938, and the beginning of demolition in 1940 (*see* inset). After the war, the site, which had been requisitioned by the military, became the present Imperial Gardens. The bandstand, seen on the left of the 1938 photograph, was sold in 1948 to Bognor Regis, where it can still be seen.

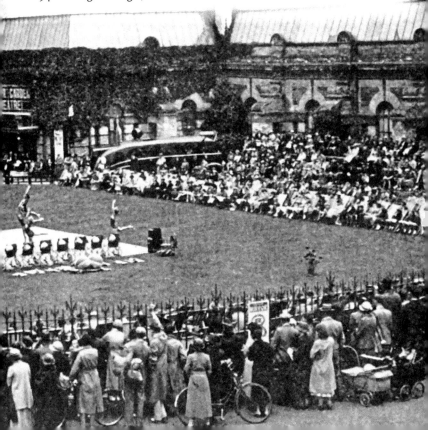

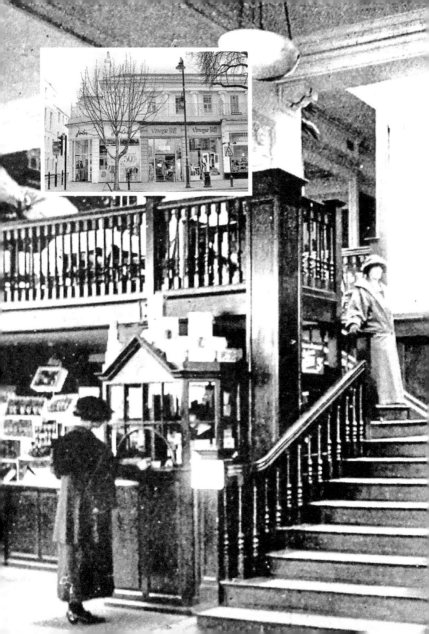

## 27. CADENA CAFÉ

Shown here in 1923, after being completely refitted, is the Cadena Café in the Promenade. Occupying the lower floors of Belgrave House, whose handsome entrance can still be seen around the corner in Imperial Square, it was originally a boarding house for fashionable visitors to the Spa. In 1919, Cadena Cafés Ltd took over Mr E. E. Marfell's Cosy Corner café and immediately applied for a music licence allowing those partaking of morning coffee, luncheon or afternoon tea, to be entertained by a trio. Today, the former Cadena premises house three retailers of high-quality fashion.

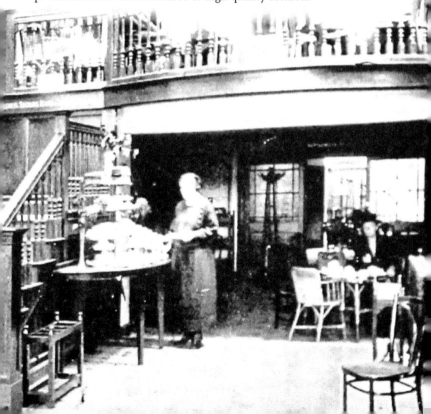

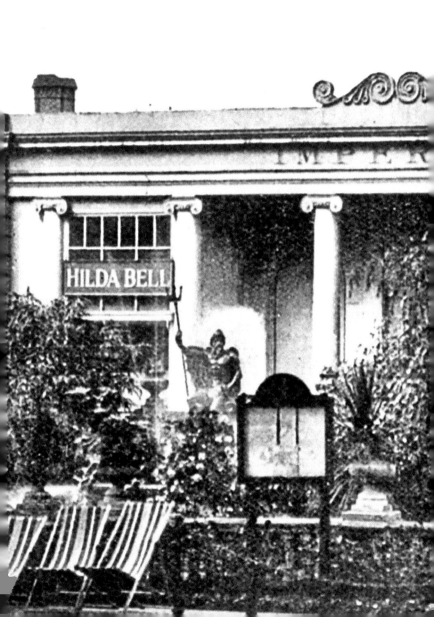

## 28. IMPERIAL SPA

The Sherborne or Imperial Spa stood at the head of the Promenade, which was the area for visitors to exercise by 'promenading' for the waters to take effect. With the building of the Queen's Hotel, the spa building was re-erected as the Imperial Rooms at the corner of St George's Road. Using water from the underground River Chelt, the Neptune fountain was added in 1893; the Borough Surveyor was said to have drawn his inspiration from the Trevi Fountain in Rome. The rooms are shown here in September 1937, immediately prior to their demolition to make way for the Regal Cinema.

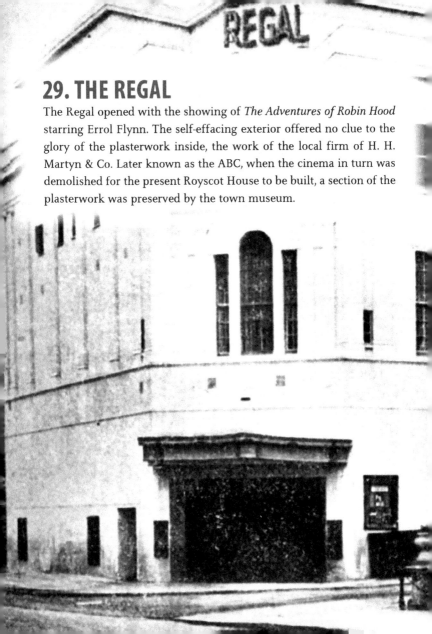

# 29. THE REGAL

The Regal opened with the showing of *The Adventures of Robin Hood* starring Errol Flynn. The self-effacing exterior offered no clue to the glory of the plasterwork inside, the work of the local firm of H. H. Martyn & Co. Later known as the ABC, when the cinema in turn was demolished for the present Royscot House to be built, a section of the plasterwork was preserved by the town museum.

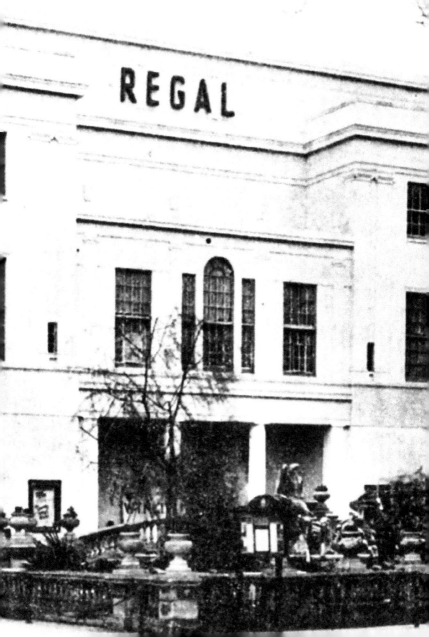

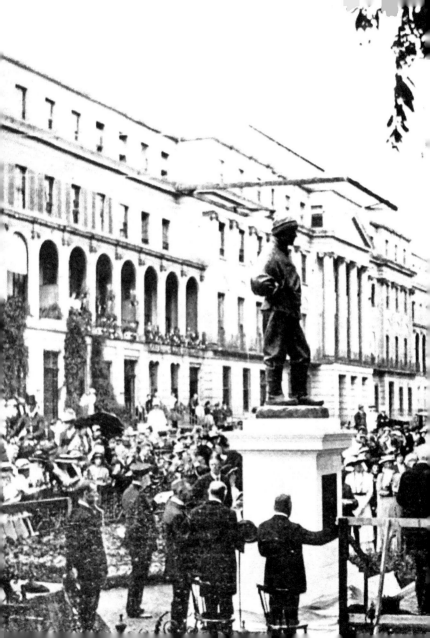

## 30. EDWARD WILSON

Born at a house in Montpellier Terrace, Edward Adrian Wilson accompanied Scott on his two Antarctic expeditions and died with him on their return from the South Pole. This view shows the unveiling of Wilson's statue in the Promenade Long Gardens in July 1914, an event attended by Wilson's widow and parents, and many of his family and friends. The statue was carved, appropriately, by Scott's widow and cast in bronze by the local firm of R. L. Boulton's. On the statue's plinth are carved Scott's words, 'He died as he lived. A brave true man. The best of comrades and staunchest of friends.'

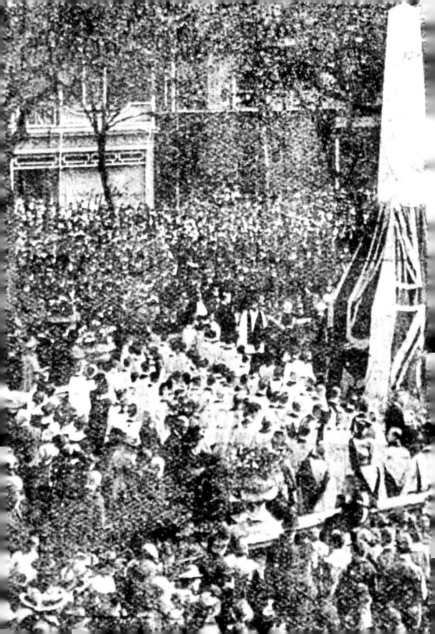

# 31. WAR MEMORIAL

With the end of the First World War in 1918, there was a movement throughout the country to commemorate those who had died in 'the war to end all wars'. In Cheltenham, several grandiose schemes had to be abandoned due to lack of funds. Eventually, a simple obelisk, 24 feet high and inscribed with the names of the fallen, was erected by R. L. Boulton and Sons. Placed immediately in front of the Municipal Offices, the memorial was unveiled by General Sir Robert Fanshawe on 1 October 1921. Following the end of the Second World War, bronze plaques listing those killed in that conflict were unveiled on 12 November 1950 by General Lord Ismay. Further memorials have been placed around the obelisk in memory of those killed in later wars and campaigns. They include a plaque to Daniel Beak, VC, who rose from the ranks to become a Major General.

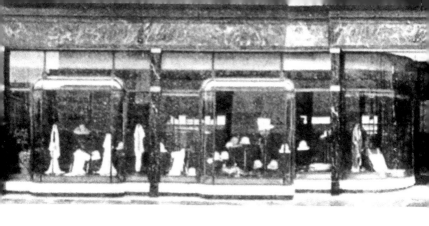

# 32. MADAME WRIGHT'S, ORMOND PLACE

Modelled on a shop she had seen in Paris, the costumier Madame Wright opened these new premises in Ormond Place (which she renamed Little Promenade) in 1925. Attracting an exclusive clientele, Madame Wright's customers included Queen Victoria's granddaughter, Princess Marie Louise, who bought her outfit here for our present Queen's wedding in 1947. The BBC used the exterior in 1991 for their television series *The House of Elliott*, but following the death of Madame Wright's son in 1995 the business closed. Today the building houses a hairdresser and a unisex shoe and clothing retailer. The former workrooms on the upper storey have been converted into flats.

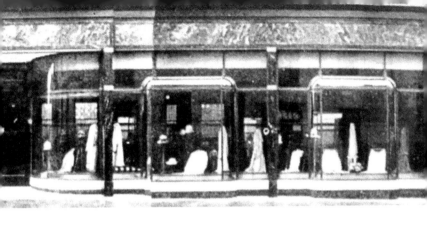

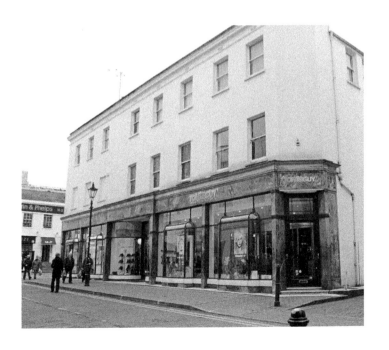

## 33. CAVENDISH HOUSE, PROMENADE

The early nineteenth-century façade of Cavendish House, the town's leading department store, shown here in the mid-1920s. Though its advertisements claimed the store had been founded in 1818, the first small shop had been opened in 1826 by Clark and Debenham from London, selling silks, muslins, lace and shawls. In the now-pedestrianised Promenade, the bland exterior of the completely rebuilt Cavendish House was designed in the 1960s by Downton and Hurst of London, destroying the character and charm of the nineteenth-century store, though local opposition to renaming the shop have so far been successful.

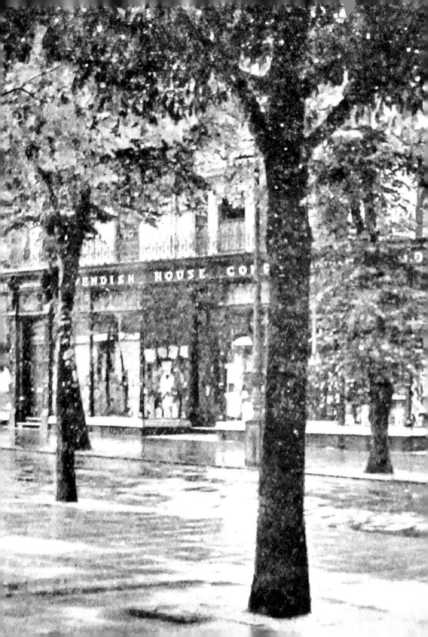

# 34. THE COLONNADE

The Colonnade, *c.* 1923, now renumbered as part of the Promenade, has its origins in a row of shops built in the 1790s. The left side was redeveloped a century later, but the right side not until the 1930s. Many of the units were occupied by the long-established department store Shirer & Haddon, who had been appointed mercers, lacemen and drapers to Queen Victoria in 1838.

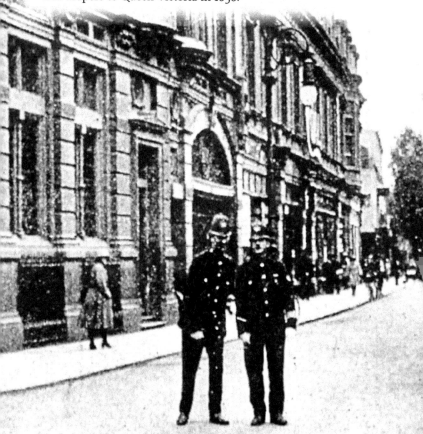

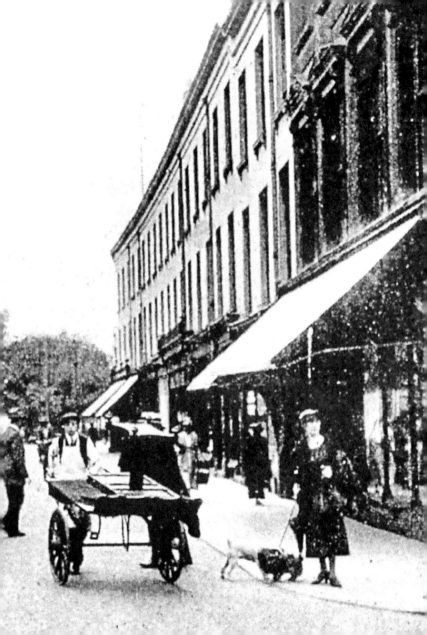

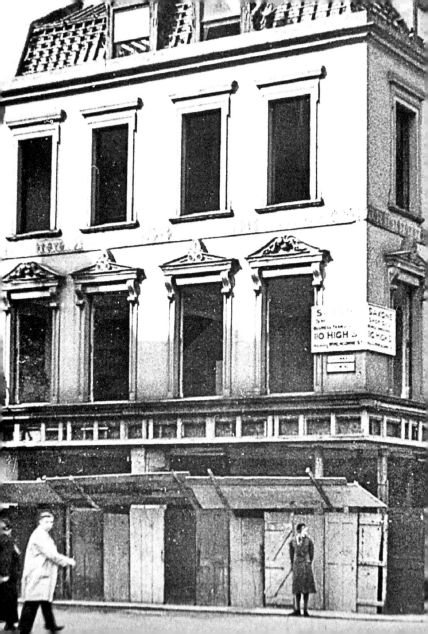

# 35. THE COLONNADE

This photograph shows the former Saxone Shoe Company premises before demolition in April 1937. Now, where customers once tried on shoes, are the pavement and a small concreted area with a fountain.

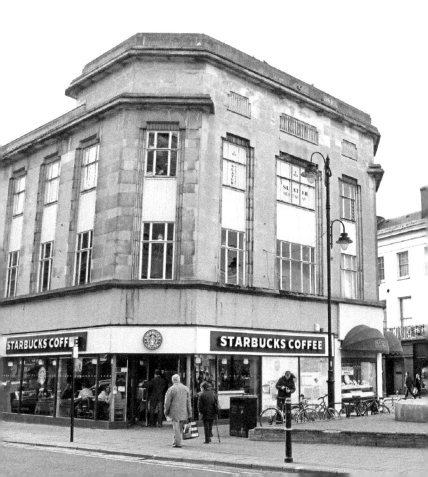

# 36. OLIVE'S SHOP

The 1911 Christmas show of Olive & Olive, fishmongers and poulterers, at their premises in the Colonnade now renumbered as part of the Promenade. Established in 1819, they were the principal game bird dealers in the town, but modern food safety regulations would surely forbid such a display, open to the dust and fumes of the road, today! Olive's shop has long been incorporated into the premises of HSBC, formerly the Midland Bank; but how many passersby notice the carving of game birds still to be seen to the left of Hooper Bolton's premises?

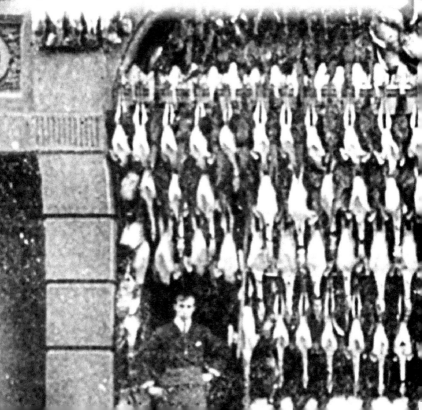

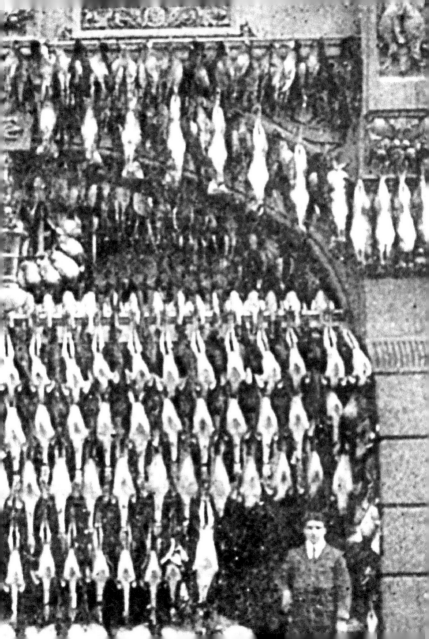

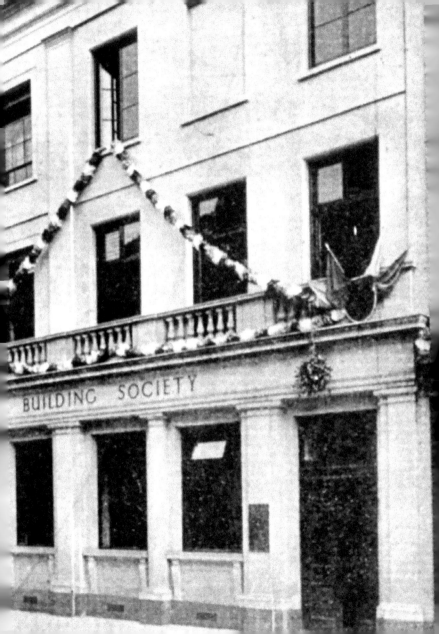

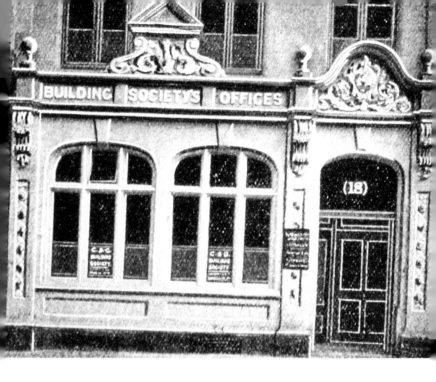

# 37. CHELTENHAM & GLOUCESTER BUILDING SOCIETY

Founded at a meeting at the Belle Vue Hotel in 1850, the Cheltenham & Gloucester Building Society expanded into a national company, eventually being acquired by Lloyds Bank. Shown here are their offices in 1907. The building society redeveloped the whole site in the 1970s, opening the present Cheltenham House in 1975, adorned with a sculpture by Barbara Hepworth.

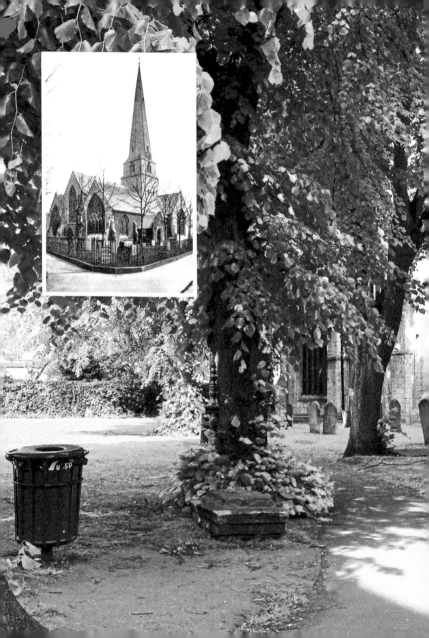

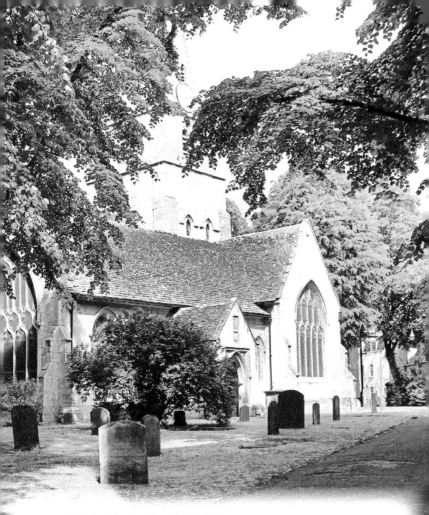

# 38. ST MARY'S CHURCH

The ancient Parish Church of St Mary, now known as the Minster, provides a haven of peace in the town centre. It is shown in the inset image before the removal of the ironwork, for armaments, in 1940.

# 39. PUBLIC LIBRARY

High and unseen by many passers-by, the pediment of the public library is surmounted by an 8-foot high statue of William Shakespeare. The work of G. Hailing, it was the gift in 1911 of R. W. Boulton, head of the local firm of ecclesiastical sculptors. The library opened on this site in 1889; the single-storey art gallery, on the right, was added in 1899 and the museum opened in 1907. Until the reorganisation of local government in 1974, it was administered as one institution under a single head, the borough librarian and curator.

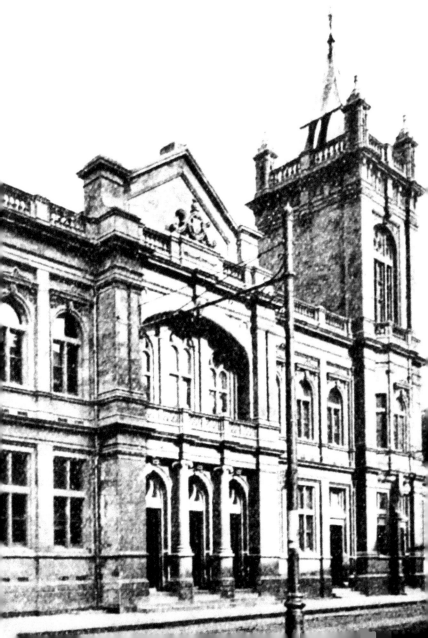

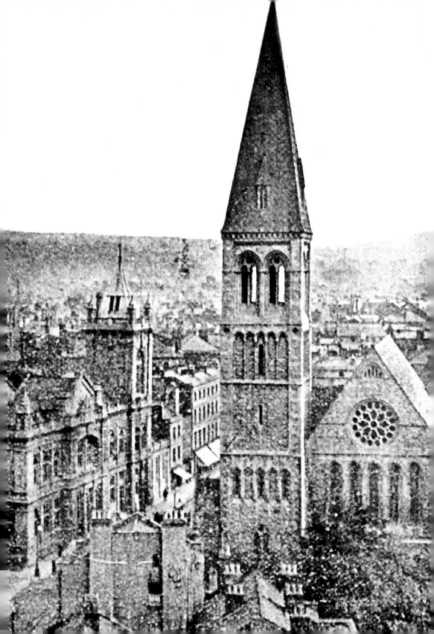

# 40. ST MATTHEW'S CHURCH

Shown in 1902, St Matthew's in Clarence Street was built as a chapel of ease to the ancient parish church of St Mary's close by. The tower was built in two stages, the lower part in 1877–79, with the spire added in 1883–84. Formerly dominating the skyline, it dwarfed the tower of the public library seen on the left. By the early 1950s, the spire had become unsafe and was removed in 1952. Twenty years later, concern for its safety led to the removal of the remainder of the tower. Since 1972, when the congregation of Wesley Chapel in St George's Street came to share the building, the space under the tower has been known as the John Wesley Room.

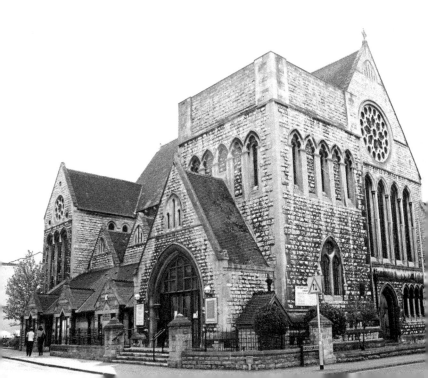

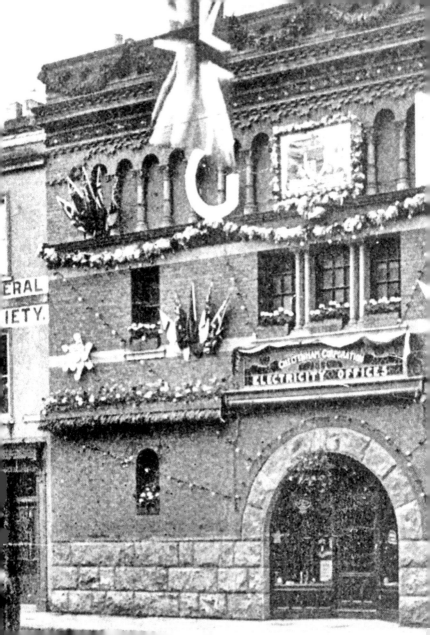

# 41. ELECTRICITY OFFICES, CLARENCE STREET

The Cheltenham electricity offices in Manchester Street (now re-numbered as part of Clarence Street) were decorated for the Coronation of George V and Queen Mary in 1911. Built as the principal substation to the electricity works at Arle, the upper stories were added in 1900 and used as offices from 1907 until 1915. A plaque commemorating its use as the town's first and principal substation was unveiled in 1986 by Revd Wilbert Awdry, the author of the Thomas the Tank Engine books. The building was converted into an apartment hotel in 2008, its Italianate architecture, reminiscent of a Florentine palazzo, led the owners to name it the Strozzi Palace.

# 42. FIRE STATION

A new fire station was opened in 1906 in St James' Square, adjoining the existing engine house. Twenty years after the outbreak of the Second World War, the fire service moved to new premises in Keynsham Road. Today both the old engine house and station have been converted into an upmarket restaurant.

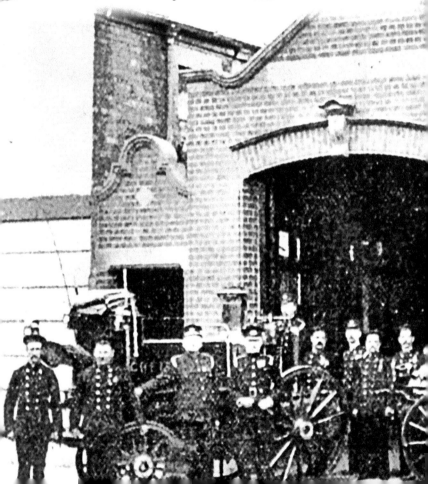

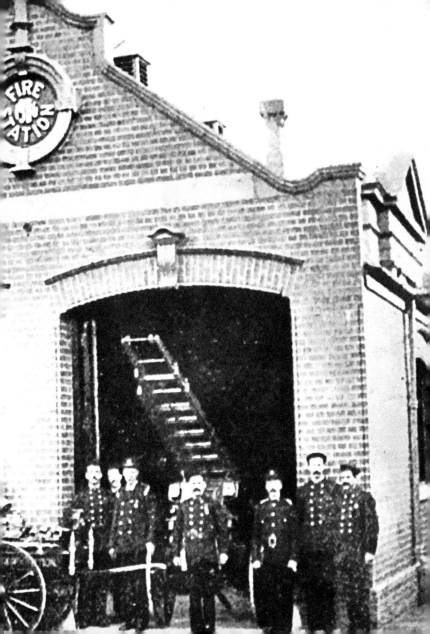

Also available from Amberley Publishing

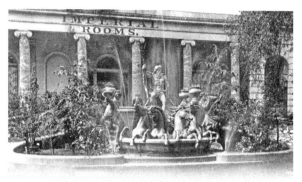

ROGER BEACHAM & LYNNE CLEAVER

# CHELTENHAM

THROUGH TIME

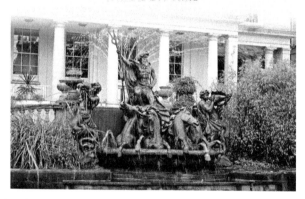

This fascinating selection of photographs traces some of the
many ways in which Cheltenham has changed and developed over the
last century.
978 1 4456 0295 0
Available to order direct 01453 847 800
www.amberley-books.com

LYNNE CLEAVER

# TETBURY &
# DISTRICT

THROUGH TIME

A charming selection of photographs that traces some of the many
ways in which Tetbury and district has changed and developed over
the last century.

978 1 8486 8932 9
Available to order direct 01453 847 800
www.amberley-books.com

THE
COTSWOLDS & SURROUNDS
A COLOURING BOOK

A beautiful collection of Cotswold images for you to
colour as you wish.
978 1 4456 5976 3
Available to order direct 01453 847 800
www.amberley-books.com